Melvin Cambettie Davies

Toning and Tinting
Made Easy

100'S OF TIPS AND HINTS TO TINTING AND TONING

Volume One

First English Edition May 1994

Published by Hove Foto Books Ltd.
Jersey Photographic Museum
Hotel de France, St. Saviour's Road, St Helier,
Jersey JE2 7LA

Printed by The Guernsey Press Company Limited,
Commercial Printing Division,
Guernsey, Channel Islands

Designed and Produced by
Colornet (CI) Limited
Longue Hougue House
Longue Hougue Lane
St. Sampsons
Guernsey
Channel Islands
GY2 4JN
Telephone 0481 42172 Fax 0481 47806

Contents

Elizabeth Davis

20·11·94.

About The Author

Melvin Cambettie Davis has had over 45 exhibitions of his work in the UK during the past five years.

His real passion is printing from glass plate negatives dating back to the 1890's and toning the images in his inimitable way.

His most recognised work "Images Of The Past" toured the UK for two years and is now on permanent show at the Agency Club in London.

Melvin regularly tours the country teaching and lecturing on phototoning techniques at various colleges, camera clubs and photographic shows.

He recently set up a black and white hand printing laboratory called Master Mono where he caters to students and professionals alike with the helping hand of Max Fergerson, a top printer in his field who also teaches and lectures.

Melvin has been printing for 29 years perfecting the art of black and white. However, the last 8 years has seen him concentrating on researching into the diverse world of toning where he has found a burning desire to expand his knowledge by studying as much as possible from his toning forefathers.

Melvin can be contacted at Master Mono on UK 071 336 7962.

Acknowledgements . . .

Fotospeed	0225 810596
Sterling Imaging	0225 812531
Martin Hooper	0860 326654
Steve Reeve	0908 220654
Jane Chilvers	071 493 0078

Note: All telephone numbers are UK. The International country code is 44.

Special Acknowledgements . . .

Helen Susan Hughs for inspiration.

Tinting and Toning

Toning is the process of converting the silver within an emulsion to another metallic compound depending on the toner being selected. The effect is in direct proportion to the density of the silver within the print from the borders which are white and therefore contain no silver and consequently will not tone, to the shadows which contain the greatest amount of silver and will take the longest to tone. If the emulsion has no silver then it will not tone. Therefore you can tone black and white emulsions but colour prints cannot be toned

Toning is a process which can be applied to any black and white emulsion whether it is film or paper. The toning process begins with a well fixed and well washed print. If the print is old and there is any doubt whether it was originally well fixed and washed, then it should be refixed and washed well prior to toning.

In the early days of photography the only way to add colour to the final print was by toning and hand tinting. Wonderful techniques and colours were developed by those early photographers who would prepare potent and often smelly brews of chemical to create their exquisit images. We are not attempting to recreate these old ways but have brought the formulae and user friendliness of the solutions up to date so that modern papers can be used in the search for creative effects.

Many of the old colouring techniques were discarded with the advent of colour film. In recent years many photographers, confined by the limitations of colour film and inspired by a desire to create an altogether different and personal colour, mood and quality to their prints, have generated a revival of old photographic toning and tinting techniques.

Today's modern chemicals and technology has meant that these techniques have been improved and expanded. With the huge variety of modern papers and developers available, the exact quality of print for toning can be easily produced. Toning and tinting formulae have been carefully refined and improved to suit modern papers, and they have been expanded to make available many more colours and hues. New masking fluids and dyes mean that several techniques can be applied to a single print.

Toning and tinting is not an exact science, the final print will be determined by personal preference.

In this book we will analyse some of the toning techniques used.

Why Tint and Tone ?

The application of toners and tints to monochrome prints allows the use of colour which is not naturally available to the image. The tones and tints can be applied as an overall hue or selectively to desired areas, creating moods, depths and quality to the image. For example, village scenes can be taken back a generation by use of sepia toner. Waterscapes can be given an etherial emptiness by split toning with blue and sepia. Surealism can be achieved by introducing differing tones to enhance the print. With some techniques toners will appear to

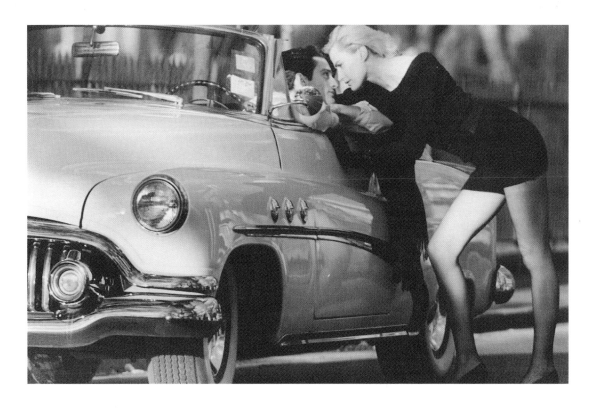

add a third dimension to a print tempting the viewer to reach in and touch the image.

Toners and tints can produce images which have been subtlety or dramatically altered to a colour completely opposite to those which are found naturally. Fruit and flowers can look very magical when toned and tinted in this way. Hand tinting allows precise application of colour to images exactly where desired. One person in a crowd for instance can be brought to life by the application of toner and tints to clothes and face. A shabby building can be brought to life with the judicious application of colour.

Each toned and tinted print is a creative work of art. Reproducibility is possible but each print can have its own personal identification by being slightly different from the others.

Toning should not be viewed as a means of rescuing a failed black and white print. To produce good toned prints you should print for a specific toner or final effect. The details of this are described in the relevant toner sections.

Choice of Paper.

There are many types of black and white paper available to the user and all are suitable for toning. Some are more receptive to the toners and therefore produce a richer shade of colour. Others take longer to react with the toner and produce less vibrant shades.

Resin coated papers are easier to handle but there is a change of tonal vibrance due to the resin coating and lighter coating weight as compared to fibre based paper. As a general rule chlorobromide fibre based papers will produce the most vibrant tones but the fibre base makes them less easy to work with as they require infinitely more washing and careful handling.

Graded papers will differ in their acceptance of toner according to the grade. As toners react to the silver within the paper the higher the grade the more vibrant the tone and a loss of subtlety. Again, the difference between fibre based and resin coated graded papers applies as it does for the chlorobromide papers.

Variable contrast papers are the most popular. Their versatility is achieved through a complex structure of emulsions and this makes them the slowest to react to the toning process. More time is needed for the toners to penetrate the layers to the black silver and in comparison to the chlorobromide papers, the vibrance of the tones is not as great. There is however an exception to this rule. The exception is the paper used for the working examples in this book – STERLING RC–VC. This is a resin coated, variable contrast paper but with a chlorobromide emulsion. This gives the paper a warmer tone than conventional bromide papers and a sensitivity to toners that makes it a delight to work with.

Each type of paper has it's own characteristics. The more silver in the paper the more the toner will react and produce richer tones. If the paper is developer incorporated, then this will also have an effect on the final tone of the print appearing in

some cases to make the tone a shade darker.

To find the paper best suited to your expectations, a little bit of trial and error is called for.

Printing for Toning.

The chemical nature of toners requires them to work in one of two ways.

As a two bath working solution or as a single working solution. The single bath toners bleach and tone simultaneously. The two bath toners bleach in the first bath and tone in the second bath but the toner will only tone the silver which has been bleached.

The two processes work in different ways and therefore effect the print differently. Printing to suit each toner can improve the finished result. As each toner is discussed, there will be hints on printing to suit that toner.

Dish or Machine Processed Prints ?

Both dish and machine processed monochrome prints are suitable for toning.

It is generally agreed that dish processed prints can exhibit a greater tonal range than machine processed prints.

If there is any doubt as to the efficiency of the machine to fix and wash the print, then it is recommended that the print be refixed and rewashed in dishes prior to toning.

General Hints.

Always observe strict standards of cleanliness ensuring that one solution does not contaminate another. When moving a print from one solution to the next, always wash the print well between each solution (unless otherwise stated). Do not let your hands contaminate each solution as this may reduce the effectiveness and life of the toning solutions. Ideally and for your health, always wear gloves or use tongs and a recommended chemical barrier cream. Always work in a well ventilated area and after using any chemicals always wash your hands well with soap and water and after drying well apply a hand moisturising cream.

Toning solutions will oxidise in the open dish. The larger the dish the more rapidly oxidisation will occur and the life of the toner will be shorter. If you are toning large prints ensure that you have enough working solution to fully emerse the print. If there is insufficient solution uneven take-up will occur and streaking may happen. Gentle agitation of solutions is essential.

Only process one print at a time to avoid disfiguration effects. Never over work a toner. Where possible use fresh solutions and only mix up the required quantities of working solution as, generally working solutions will not keep. Never mix concentrates together.

Always follow the health and safety guide lines with each kit.

SEPIA TONING

Fotospeed ST20 Odourless Vario Sepia Toner

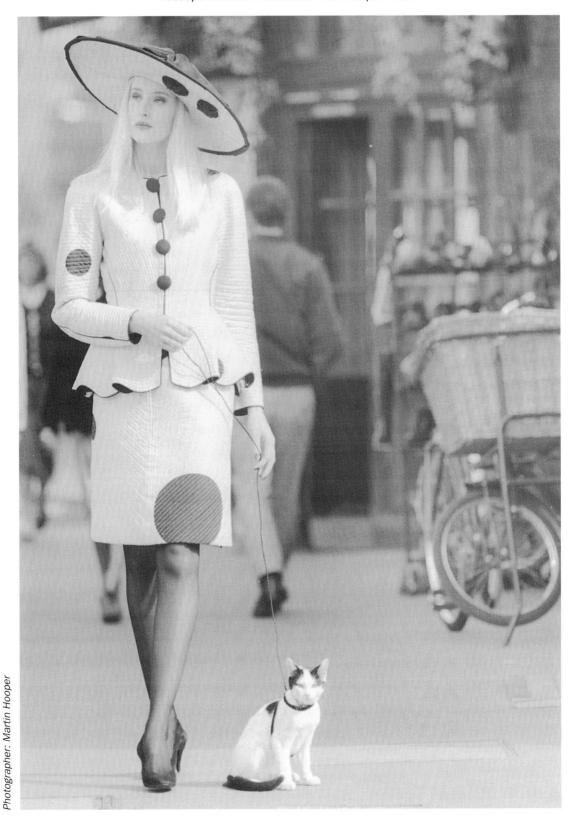

Photographer: Martin Hooper

Printed on STERLING RC-VC, developed in Fotospeed DV10 Varigrade Print Developer, Fixed in Fotospeed FX20 Rapid Fixer and toned in Fotospeed ST20 Sepia Toner with 25mls/Ltr of part 3 additive.

Fotospeed ST20 Sepia Toner is a two bath sepia toner supplied in a three part concentrate. The first part is the bleach bath, the second part is the toning solution and the third part is the toner additive which when added to the working solution toner changes the shade of the tone from yellow sepia to dark brown. Sepia toning with ST20 is achieved by first placing the print in the bleach solution, when the required bleaching has taken place the print is then washed and placed into the toning solution for 1-3 minutes, then washed thoroughly and dried naturally.

Bleaching.

The bleach bath removes the black silver in the print. This is necessary as the sepia toner will only take up where silver has been removed. The length of time the print is left in the bleach and therefore the amount of silver removed will in itself affect the final shade of tone. Bleaching times can vary according to desired effect, however, even a fully bleached print will still have a light image remaining. Full bleaching time will depend on the type of paper and the density of the image. If you want the bleaching time to speed up then make up the bleach stronger and visa versa.

Bleaching reduces the image, visually appearing to remove the highlights first but still attacking the shadow areas simultaneously. If left long enough the highlights will disappear completely followed by the shadows. The sepia toner will only replace the bleached parts. Unbleached silver will not be effected by the toner.

If the print is given a relatively short bleach so the highlights are fully bleached but the shadows are only partially bleached, when the print is toned it will appear that the highlights have been fully toned and the shadows only slightly touched. This is in effect a form of split toning (sepia/black&white). If the print is fully bleached the toned print will have a more overall sepia colour.

When bleaching a print which has large areas of highlight next to dark shadows, if you leave the print in the bleach for a short time you will retain detail in the highlights but have less detail in the shadows. However if you leave a print longer in the bleach, when it is toned you may have lost detail in the highlights but you will have gained detail in the shadow areas which would have been lost in the original print. In effect you can use the bleach as a reducer since the toner will not completely replace the image if it has been over bleached.

When using variable toner there are two things to consider. Firstly, you can decide the shade of sepia you wish to achieve and secondly, you can alter the density of the print during bleaching and therefore the depth of the tone you wish to achieve.

Toning.

The Toning solution is made up by diluting the toner (part2) with water and then adding part 3 concentrate directly into the diluted part 2. Part 3 is the additive which determines the shade of sepia tone, from a light yellow to a rich chocolate brown. The less part 3 added the lighter or yellower shade of sepia will result. It is necessary to add part 3 to the diluted part 2 solution as a small amount is needed to activate the toner. If no part 3 is added there will be no toning effect.

Partial Bleaching versus total bleaching:

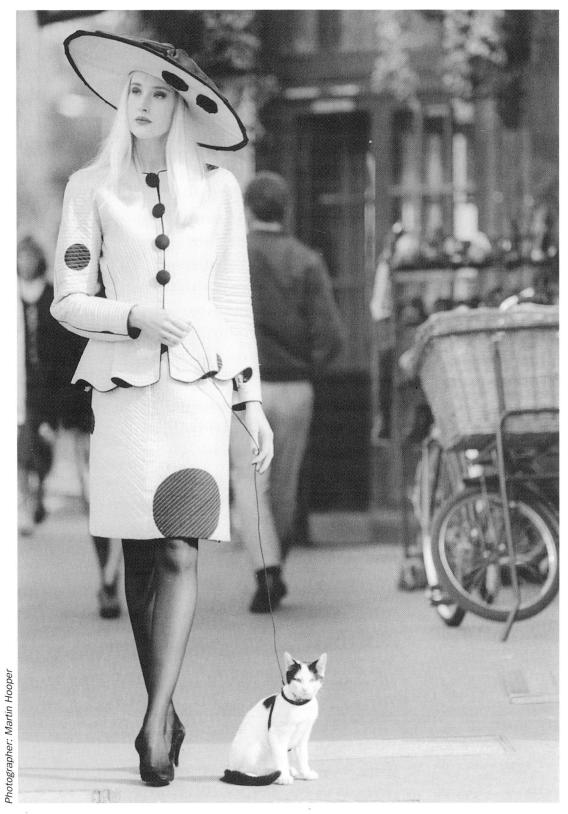

Photographer: Martin Hooper

FIGURE 1
Black and White print untoned.

Photographer: Martin Hooper

FIGURE 2
The Black and White print was fully bleached until there was no black image. The visible image is now a faint buff brown. The sepia bleach was diluted at 1+9. After bleaching the print was washed in running water for 1 minute.

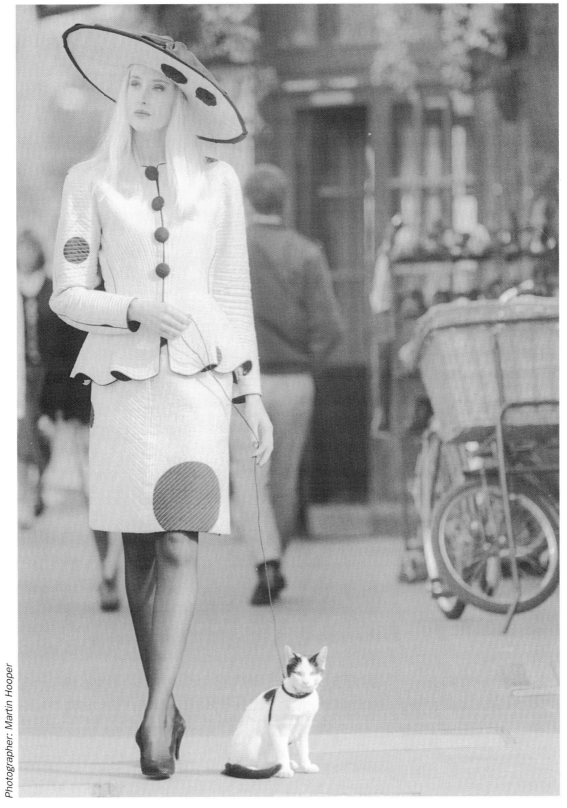

Photographer: Martin Hooper

FIGURE 3
The fully bleached print was placed in the toner solution diluted 1+9 with 25mls/Ltr of part 3 added. The print was left in toner for 1 minute, then washed in running water for 3 minutes finally dried naturally.

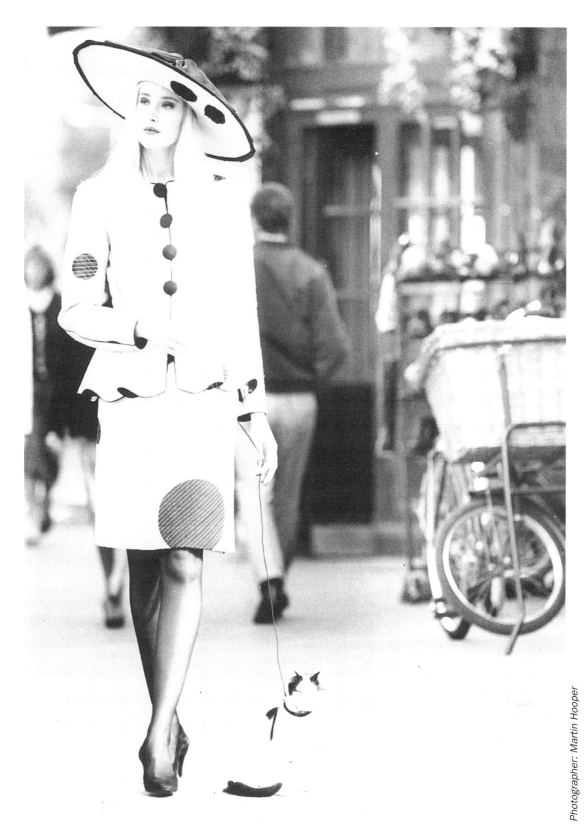

Photographer: Martin Hooper

FIGURE 4

The print was placed in the sepia bleach until the highlights were fully bleached and the bleach had just begun to attack the midtones. Notice that there is a lot of silver retained in the shadow area. Print then given a 1 minute wash in running water.

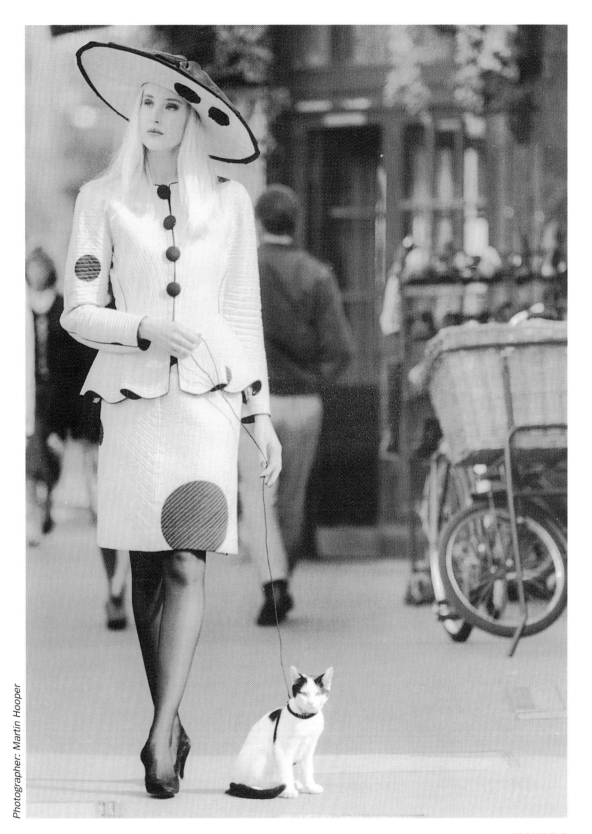

Photographer: Martin Hooper

FIGURE 5

The partially bleached print was placed in the toner solution (diluted 1+9 with 25mls/Ltr of part 3 added.) for 1 minute then washed in running water for 2 minutes. Notice and compare the result to the toned print in Fig.3. which was fully bleached. Both prints went through the same toner solution. The highlight areas, particularly the pavement, shows the same shade of sepia in both prints. However the shadow areas in Fig. 5. appear black due to the remaining silver whereas in Fig. 3. the overal image is sepia. The different appearance is soley due to the difference in bleaching times.

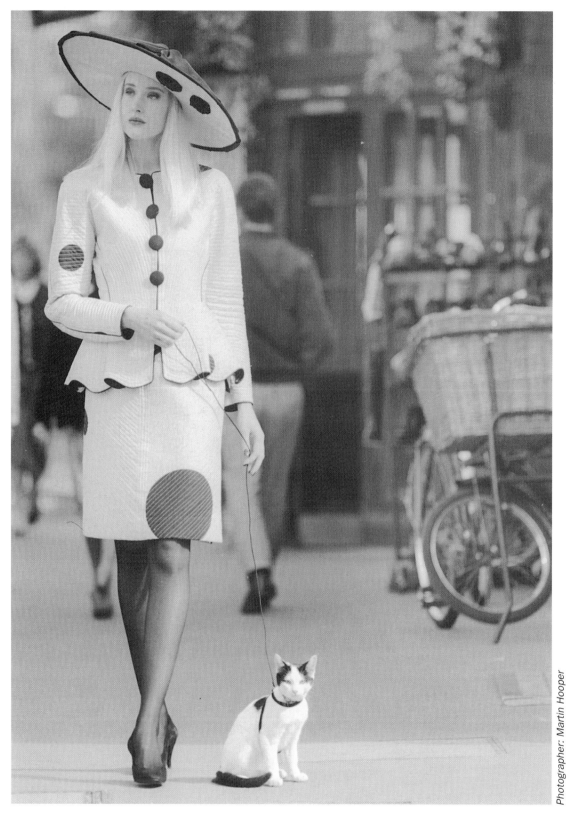

Photographer: Martin Hooper

FIGURE 6
The fully bleached print as per Fig. 2. was placed in toner solution (diluted 1+9 with 65mls/Ltr of part 3 additive) for 1 minute to give a midbrown tone to the print. Print washed for 3 minutes in running water.

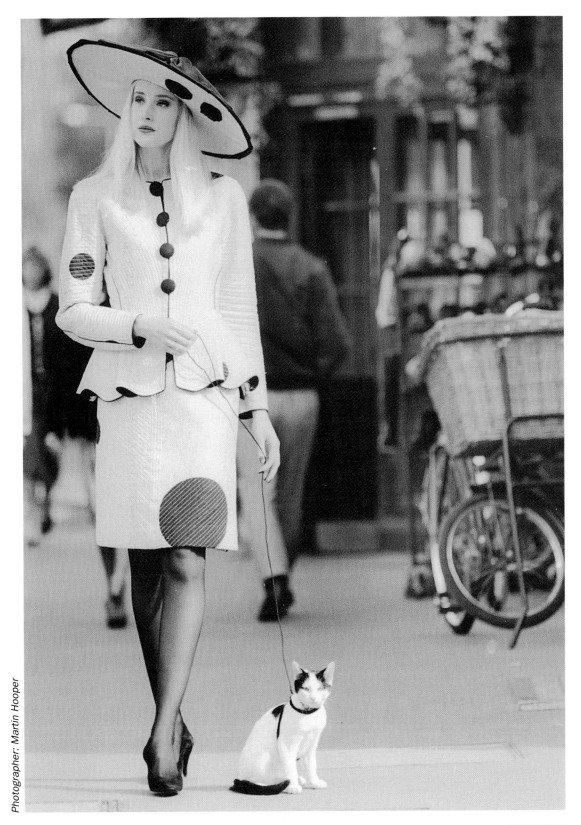

Photographer: Martin Hooper

FIGURE 7
The partially bleached print as per Fig. 4. was placed in the toner solution (diluted 1+9 with 65mls of part 3 additive) for 1 minute to give a midbrown tone to the print. Print was washed for 3 minutes in running water. Even though the toner shade is the same in both prints, the retained silver in the shadow areas of the partially bleached print gives the image a different appearance.

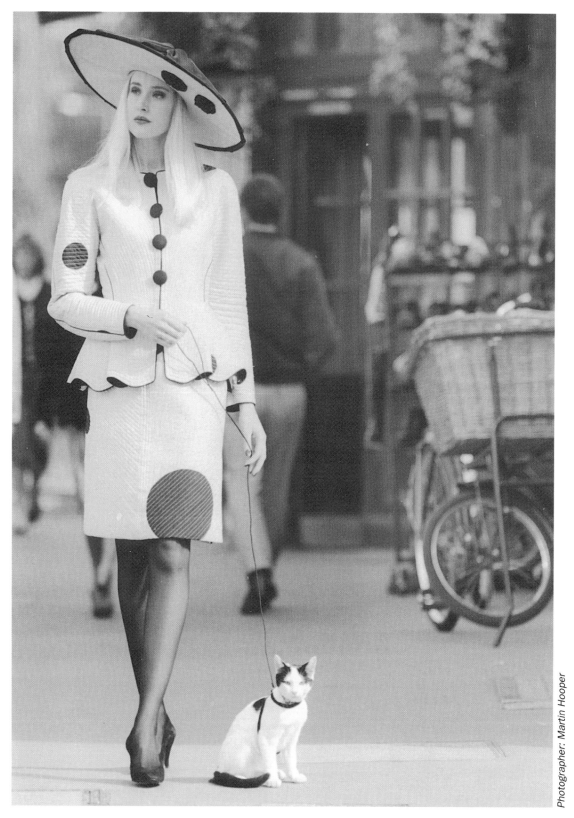

Photographer: Martin Hooper

FIGURE 8
The fully bleached print as per Fig. 2. was placed in the toner solution (diluted 1+9 with 100mls/Ltr of part 3 additive) for 1 minute to give a dark brown tone to the print. Print then washed for 3 minutes in running water.

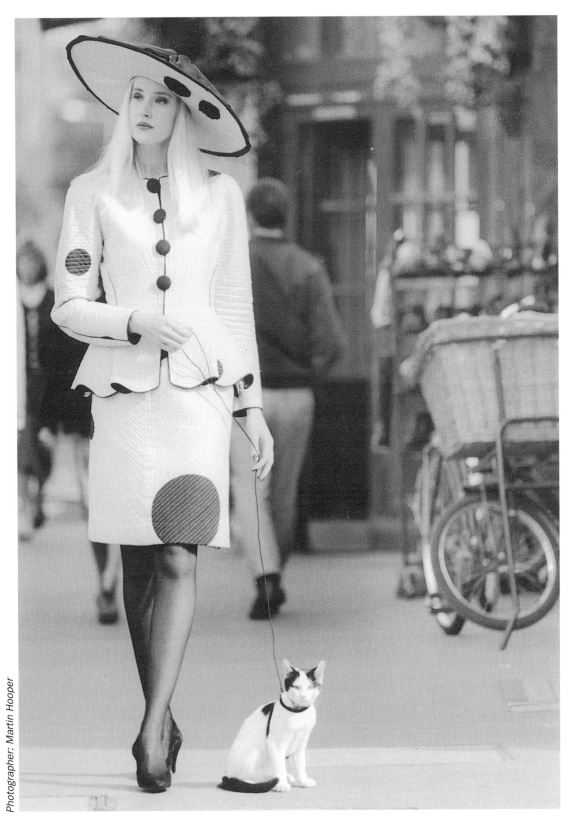

Photographer: Martin Hooper

FIGURE 9

The partially bleached print as per Fig. 4. was placed in the toner solution (diluted 1+9 with 100mls/Ltr of part 3 additive) for 1 minute to give a dark brown tone to the print. The effect of partial and full bleaching between the two prints is less dramatic here as the contrast between the dark brown sepia hue and the retained black silver has less contrast than the yellow-brown and black silver, as created in Fig. 5.

Sepia Toned, then Antique Dyed.

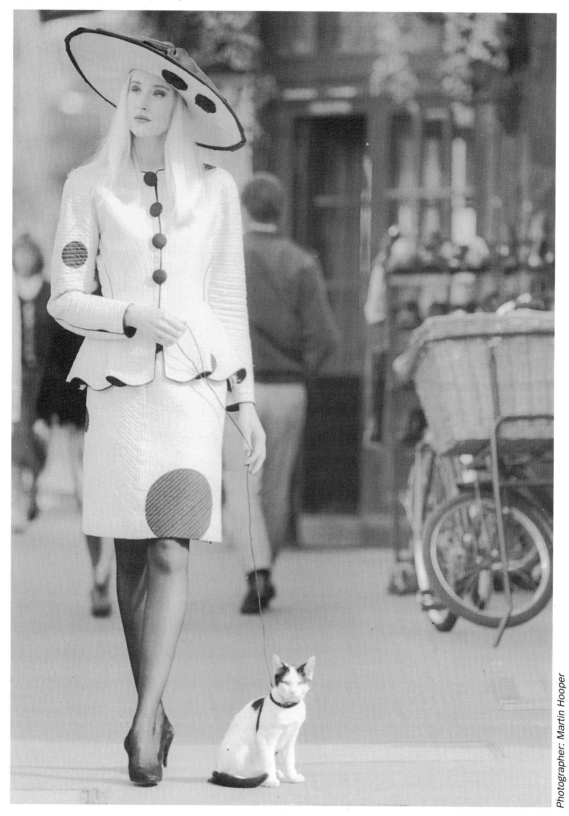

Photographer: Martin Hooper

FIGURE 10

The fully bleached print was placed in the toner solution (diluted 1+9 with 25mls/Ltr of part 3 additive) for 1 minute then washed for 3 minutes.

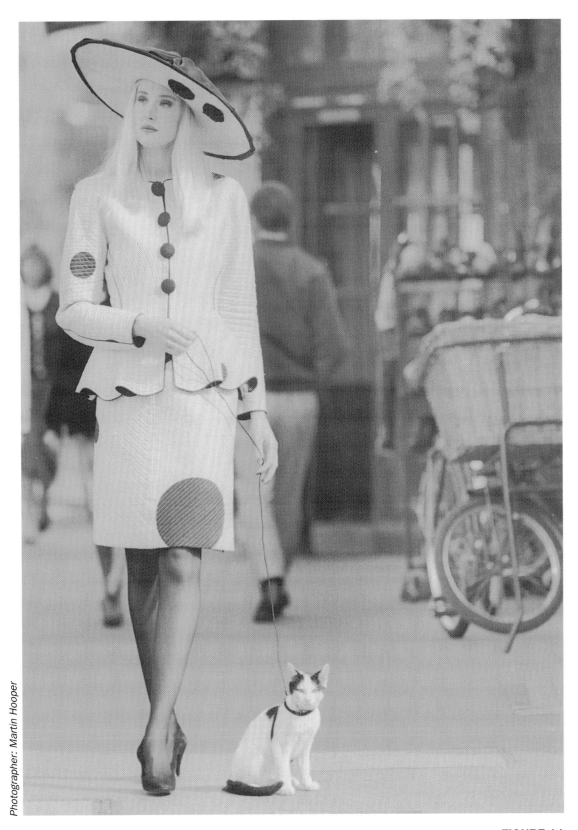

Photographer: Martin Hooper

FIGURE 11

The print from Fig.10. was then passed through Antique Dye. Unlike toners, the antique dye stains the whole print with a 'nicotine' stain. Notice how all the white areas have taken up the dye. The effect of antique dye gives prints an ancient and mature appearance. This is particularly effective with old images. Antique dye can be used creatively with any toner or indeed with a plain black and white print.

Bleaching techniques for Sepia Toning.

The importance of bleaching cannot be overstressed. Control of the bleach is very important and therefore the solution should be made up to a strength you can control. There is no advantage to having the bleach so strong that it instantly destroys the image.

Make up the bleach to the manufacturers instructions and test its effectiveness with spare prints of similar density to the print to be finally toned. Time how long it takes to remove the required amount of image for your toning needs. If it's too strong add more water, if it's too weak add more bleach, and time again. Compare the difference and keep notes as this will assist you when toning in the future.

Each type of paper has its own characteristics and bleaching times will vary from brand to brand. This is due to the silver content and the surface of the material. Whatever your prefered paper, test the bleaching effect before toning.

Because there is an almost limitless combination of solutions available you should keep notes of the solution quantites used as this will assist you in reproducing your preferred final result.

As already mentioned the sepia toner will only tone silver which has been bleached. When choosing a print to be sepia toned, be aware of the options open to you with this toner. Do you partially bleach or fully bleach? Do you make the tone yellow brown or dark brown or a shade between? You could even just 'warm' a print by giving it a very brief bleach so that only the highlights are touched. When toned in a yellow brown sepia shade, the print will appear to have been produced on a warm tone paper.

Split Toning with Sepia.

The art of split toning with sepia toner is in the bleaching of the print. By partial bleaching you leave silver in the sepia toned print for the next toner to take to.

Sepia / Blue Split Toning.

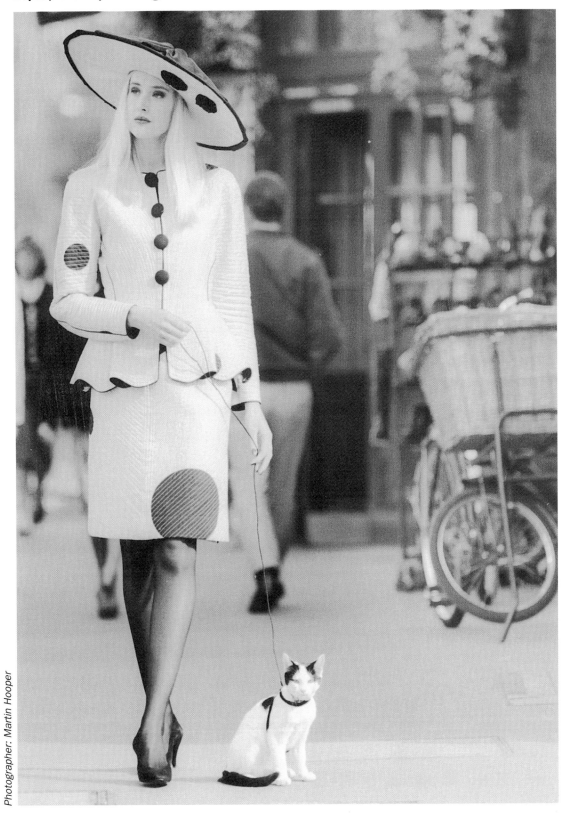

Photographer: Martin Hooper

FIGURE 12
Sepia split with blue. Sepia in the highlights and mid tones, blue in the shadows. See Figs. 13, 14, 15 & 16 to see how it was done.

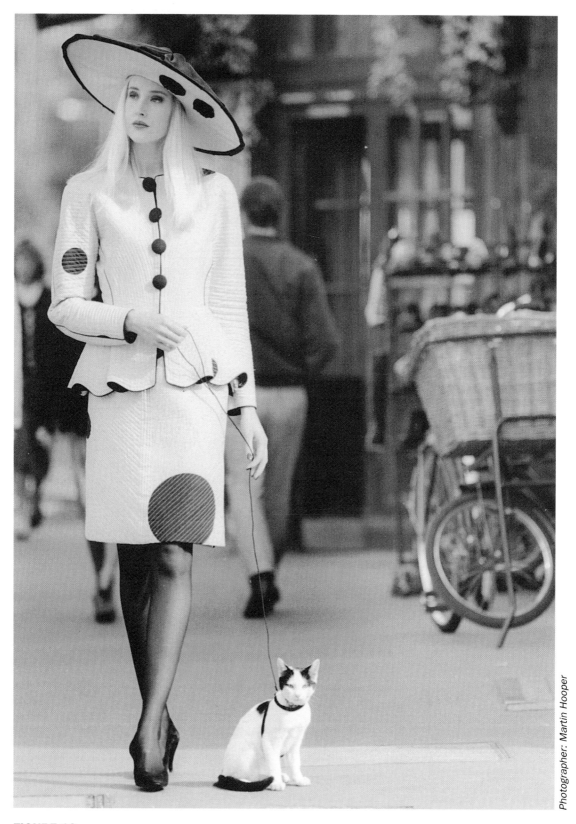

FIGURE 13
Black and White untoned print.

Photographer: Martin Hooper

Photographer: Martin Hooper

FIGURE 14

Print placed in sepia bleach until the highlights were fully bleached but the bleach has only just begun to attack the midtones (as in Fig. 4.). The print was then washed for 1 minute in running water

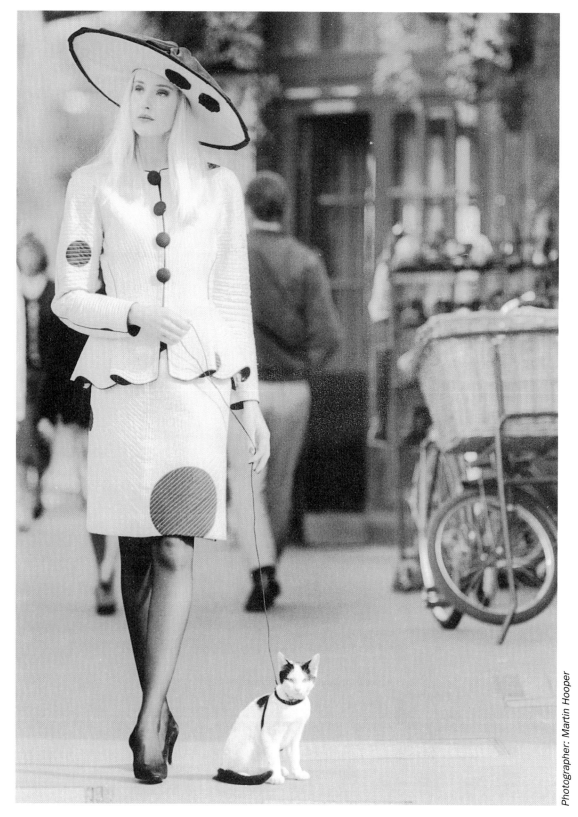

Photographer: Martin Hooper

FIGURE 15
The print was placed in sepia toner solution (diluted 1+9 with 25mls/Ltr of additive part 3.) for 1 minute (as in Fig. 5.). This is in effect split sepia / black and white at this stage. Print then washed for 3 minutes in running water.

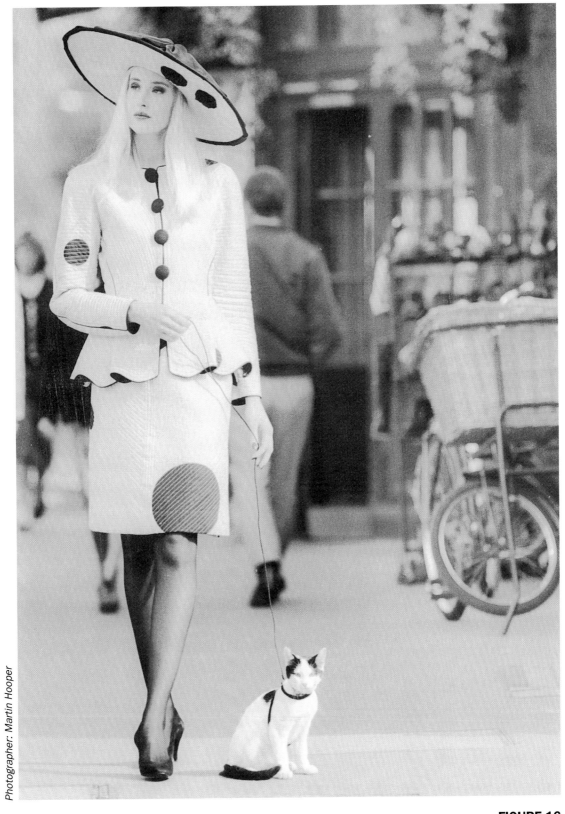

Photographer: Martin Hooper

FIGURE 16

The print was then placed into blue toner (diluted part 1 - 50ml, part 2 50ml, part 3 - 50ml added to 300ml of water to make the single working solution) for 3 minutes. Finally washed in running water for 3 minutes and allowed to dry naturally.

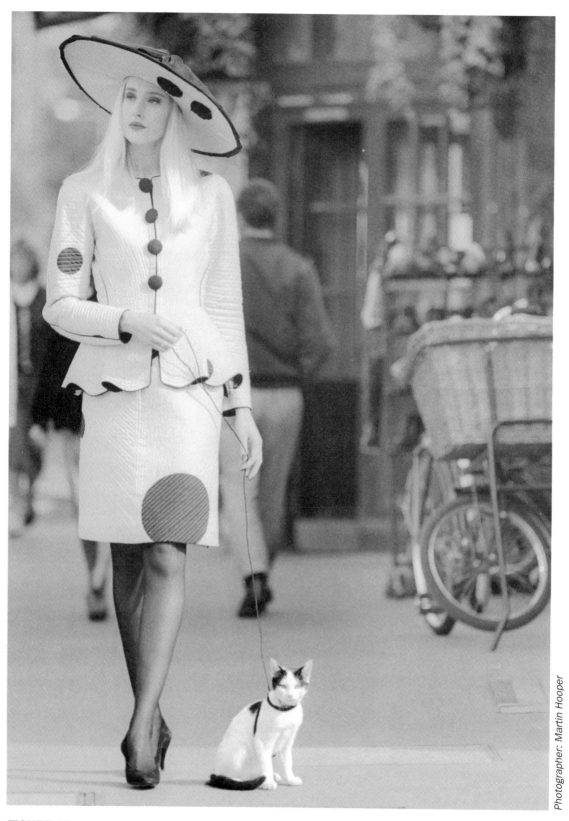

FIGURE 17

What a perfect green tone! This print is another example of a sepia blue split. In this case the print has been fully bleached (not partially bleached as in Fig. 12.) and then placed in the sepia toner solution (diluted 1+9 with25ml/Ltr of additive part 3) for 1 minute. Washed well for 3 minutes and finally placed in the blue toner (as previous dilution) for 8 minutes, washed well for 3 minutes in running water and allowed to dry naturally.

Photographer: Martin Hooper

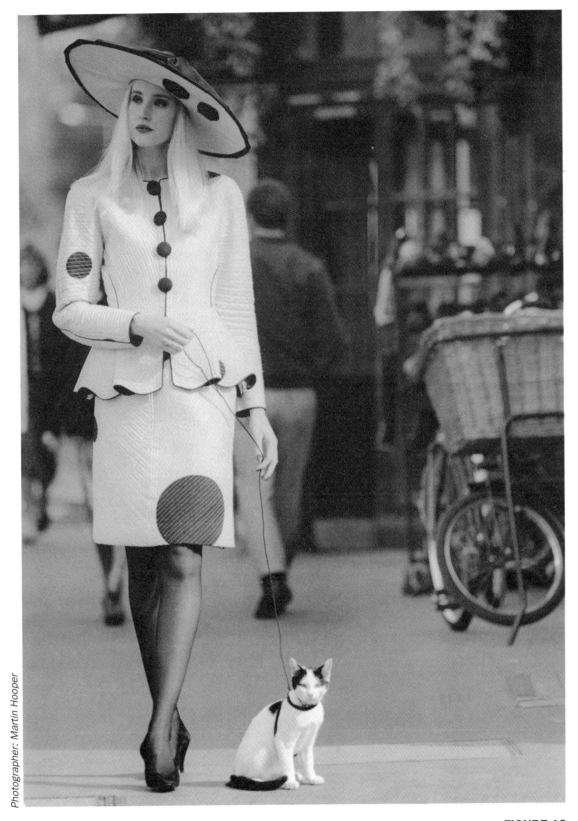

FIGURE 18

The partially bleached print was placed in sepia toner solution (diluted 1+9 with 25mls/Ltr of part 3 additive) for 1 minute. Washed for 3 minutes in running water and then placed into SLT20 Selenium Toner (diluted 1+3) for 5 minutes. Finally washed in running water for 3 minutes and allowed to dry naturally. Notice how rich the browns are compared to the standard sepia print.

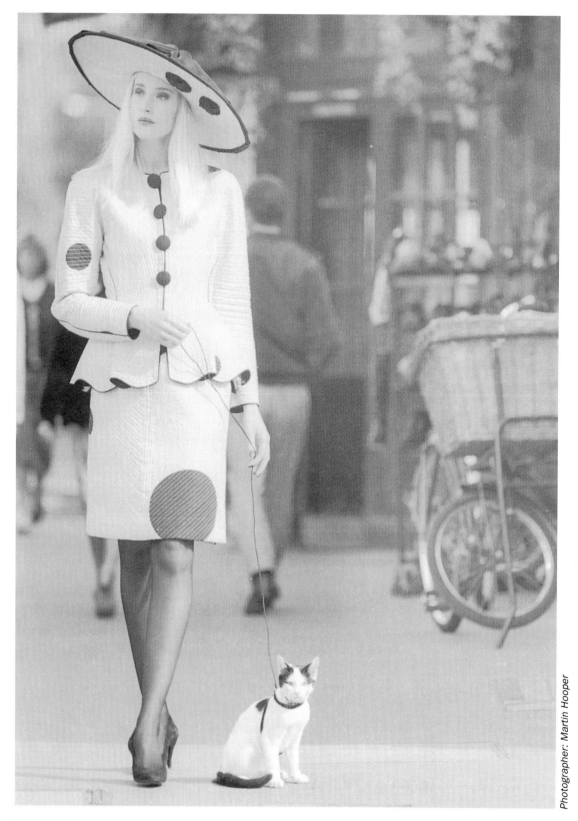

Photographer: Martin Hooper

FIGURE 19

The partially bleached print was placed into sepia toner solution (diluted 1+9 with 25mls/Ltr of part 3 additive) for 1 minute. Washed for 3 minutes in running water and then placed into RT20 Copper/Red Toner at standard dilution for 8 minutes. Finally washed in running water for 3 minutes and allowed to dry naturally. Notice how red brown the image is compared with the standard sepia print

BLUE TONING

Fotospeed BT20 Blue Toner.

Photographer: Martin Hooper

Printed on STERLING RC-VC, developed in Fotospeed DV10 Varigrade Print Developer, Fixed in Fotospeed FX20 Rapid Fixer and toned in Fotospeed BT20 Blue Toner diluted part 1 50mls, part 2 50mls, part 3 50mls added to 300mls of water to make the single working solution of 450mls.

Fotospeed BT20 Blue toner is a three part concentrate which is made up to a single working solution. The three concentrates in the kit are combined together according to the mixing instructions to form the single working solution. The standard dilution is 6 parts water to 1 part of each of the concentrates. In other words each concentrate mixes with two parts water and then all is mixed together to make a single working solution. The simplist method is to measure the required amount of water in a measuring cylinder and add the concenrtrates to the water in order stirring between additions. However the dilution can be adjusted which will effect the shade and density of the blue. Making the mixture stronger will make the shade of blue darker and conversely a weaker solution will produce a more subtle shade of blue.

As with other single working solution toners, blue toner bleaches and tones similtaneously. As the bleaching elements remove the black silver halide in the print the blue tone immediately replaces it, leaving an overall tone to the print. The longer the print is left in the solution the more toning will take place. The toner will not be absorbed by the white areas of the print. Highlight areas will appear to tone first as there is less silver for the bleach to convert, with the shadow areas taking proportionately longer.

All photographic papers will behave differently creating there own unique shade of blue tone. The different grades and types of paper within the brand will also effect the resultant shade. Each paper will react differently and therefore full blue toning will occur at different points. An average guide for variable contrast RC papers is approximately 5 minutes. Under normal conditions (room temperature, average density print, RC paper) blue toner will add density to a print. Therefore it is important that the effect of the blue toning procedure is watched especially where the print is already dense. The moment the required effect is achieved, remove the print and wash in running water to arrest the process.

Once toning has been completed, the print must be washed thoroughly to remove any of the yellow stain which may appear in the white areas. This usually takes from 2–4 minutes for resin coated papers up to 20 minutes (minimum) for fibre based papers. Washing will have an effect on the whole print, gradually reducing the over all blue tone. The washing process allows for a certain amount of shade control. To clear the whites quickly of the yellow stain without excess washing, the print can be *briefly* passed through a dish of saline solution (1 tablespoon of salt to 1 litre of water) and immediately rinsed well in running water. Always dry prints naturally as heat can alter the tone and permanence of the print.

Printing for toning.

Prints for blue toning should be printed slightly lighter to allow for the intensifying effect of the solution.

The life of the working solution is short and will be effected by the strength of the solution, the number and the denisty of the prints passed through it and how long the solution has been made up. Freshly made solution should be a light green colour. As it is used, the colour will darken until it becomes a dark blue opaque solution. It is advisable to throw the solution away once you find it clouding and difficult to see the bottom of the dish. Working solutions will not keep.

Tips.

When printing for blue toning handle the paper with extreme care from the moment you take the paper from the box. Do not touch the image area of the paper at any time taking care to handle by the edges only. Any finger marks or deposits on the print surface will be intensified by the blue toning process.

If there appears to be scum on the print after toning this is easily removed by wiping the print with a cotton wool swab containing 10% solution of stop bath, then rinsing and draining before drying naturally. When wiping prints with tissue or cotton wool make sure that there is no grit contained in the cloth or cotton wool since this can score the surface of the print.

Different types and brands of photographic paper will create a different shade of blue tone. Chlorobromide papers will generally give much richer colours and the different surfaces will also present different characteristics.

Variations in blue tone can be achieved by altering the the dilutions of the toner elements. Personal preferences can be achieved by experimenting with dilutions.

The following examples show how various shade of blue tone can be achieved.

Photographer: Martin Hooper

FIGURE 20
Black and White print untoned.

Photographer: Martin Hooper

Blue Toned for 2 minutes.
Then washed for 3 minutes
in running water.

FIGURE 21

Part 1. 50ml to 100ml water
Part 2. 50ml to 100ml water
Part 3. 50ml to 100ml water

Photographer: Martin Hooper

FIGURE 22
Blue Toned for 4 minutes.
Then washed for 3 minutes
in running water.

Part 1. 50ml to 100ml water
Part 2. 50ml to 100ml water
Part 3. 50ml to 100ml water

Photographer: Martin Hooper

FIGURE 23

Blue toned for 3 minutes.
Then washed for 3 minutes
in running water.

Part 1. 50ml to 300ml water
Part 2. 50ml to 300ml water
Part 3. 50ml to 300ml water

Photographer: Martin Hooper

FIGURE 24
Blue Toned for 6 minutes
Then washed for 3 minutes
in running water.

Part 1. 50ml to 300ml water
Part 2. 50ml to 300ml water
Part 3. 50ml to 300 ml water

Photographer: Martin Hooper

Blue Toned for 2 minutes.
Then washed for 3 minutes
in running water.

FIGURE 25
Part 1. 50ml to 50ml water
Part 2. 50ml to 50ml water
Part 3. 50ml to 50ml water

Intensifying the Blue Toner.

Intensification of the blue tone is a process aided by print developer. To achieve this effect first blue tone the print, (in this case for 3 minutes) then wash thoroughly in running water for 3 minutes. The print is then placed into print developer at the manufacturers recommended dilution until the print has fully redeveloped back to black & white. The print should be washed for 3 minutes in running water. Now the print can be placed back into the blue toner and the tone will return intensified and with a shift in the shade of the blue tone. The intensification can be continued by repeating the redevelopment procedure as before.

Photographer: Martin Hooper

FIGURE 26
Blue Toned for 4 minutes.
Then washed for 3 minutes
in running water.

Part 1. 50ml to 50ml water
Part 2. 50ml to 50ml water
Part 3. 50ml to 50ml water

Photographer: Martin Hooper

FIGURE 27

The print was blue toned (mixed 50ml of each part added to 300ml of water) for 2 minutes then washed for 3 minutes in running water. Redeveloped in print developer until the black & white image fully returned (1-2 minutes). Washed for 3 minutes in running water, then retoned in the blue toner for 2 minutes. Rewashed as before and allowed to dry naturally. You can keep repeating the procedure for redevelopment and retoning to increase the effect

Photographer: Martin Hooper

FIGURE 28
The print was blue toned as in fig 27 but left in the blue toner for 4 minutes. thereby creating a slightly different shade of blue tone.

Photographer: Martin Hooper

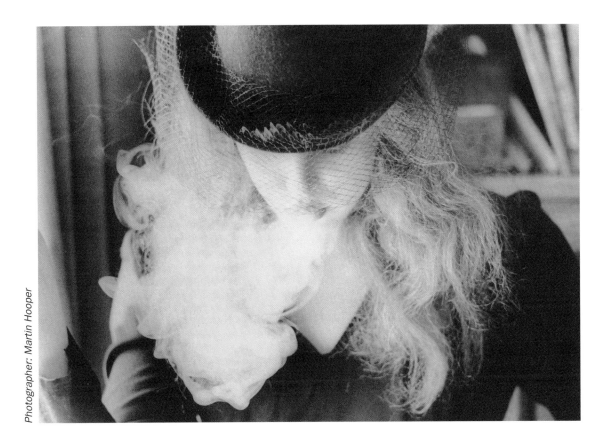

FIGURE 29

The print was blue toned (diluted 50ml part1,50ml part2, 50ml part3 to 300ml of water) for 4 minutes then washed for 3 minutes in running water. The blue toned print was then placed into sepia bleach (ST20 sepia toner part 1 diluted 1:25 ie; 20ml of bleach to 500ml of water). The colour change was observed and the print was removed from the bleach when the required colour shift was reached (in this case 1 minute) then washed in running water for 3 minutes and allowed to dry naturally.

Photographer: Martin Hooper

FIGURE 30

The print was blue toned (diluted 50ml part1,50ml part2, 50ml part3 to 300ml of water) for 4 minutes then washed for 3 minutes in running water. The blue toned print was then placed into sepia bleach (ST20 sepia toner part 1 diluted 1:25 ie; 20ml of bleach to 500ml of water). The colour change was observed and the print was removed fromthe bleach when the required colour shift was reached (in this case 1 minute) then washed in running water for 3 minutes and allowed to dry naturally.

Photographer: Martin Hooper

FIGURE 31

The print was toned as in Fig. 22, then washed for 2 minutes, placed in fixer for 2 minutes. The print was rewashed for 3 minutes, and retoned for 4 minutes. Finally washed in running water for 3 minutes and allowed to dry naturally. The blue tone, brightened by fixer, shifts the colour into a vivid shade of royal blue. The process can be repeated several times if required.

Split Toning With Blue

Photographer: Martin Hooper

FIGURE 32

The print was blue toned (diluted 50ml part 1, 50ml part 2, 50ml part 3 into 300 ml of water) for 4 minutes, washed for 3 minutes in running water and placed into SLT20 Selenium Toner (diluted 1+4) for 3 minutes. Finally washed for 3 minutes in running water and allowed to dry naturally. This split tone has bought the highlights almost to black and white with just a hint of blue.

Photographer: Martin Hooper

FIGURE 33

The print was blue toned (diluted 50ml part 1, 50ml part 2, 50ml part 3 to 300ml of water) for 4 minutes, washed for 3 minutes in running water then placed into RT20 Copper/Red Toner (diluted 1+4) for 8 minutes. The print was then washed for 3 minutes in running water and placed into sepia bleach (diluted 1+10) for 2 minutes. Washed again for 3 minutes before being replaced into the blue toner for 2 minutes. The print was finally washed for 3 minutes in running water and allowed to dry naturally. A warm blue with reddish highlights.

Photographer: Martin Hooper

FIGURE 34

The print was blue toned (diluted 50ml part 1, 50ml part 2, 50ml part 3 to 300ml of water) for 4 minutes then washed for 3 minutes in running water. The blue toned print was then placed into RT20 Copper/Red Toner (diluted 1+4)for 8 minutes. Washed for 3 minutes in running water and allowed to dry naturally. A cold blue with reddish highlights.

Photographer: Martin Hooper

FIGURE 35

This is not a mistake! Blue did play a part in this split tone. The print was blue toned (diluted 50ml part 1, 50ml part 2, 50ml part 3 to 300ml of water) for 2 minutes then washed for 3 minutes in running water and placed into ST20 Sepia Toner part 2 (diluted 1+9) and 40mls of additive part 3. Finally washed for 3 minutes in running water and allowed to dry naturally. A rich sepia.

COPPER/RED TONING

Fotospeed RT20 Copper/Red Toner.

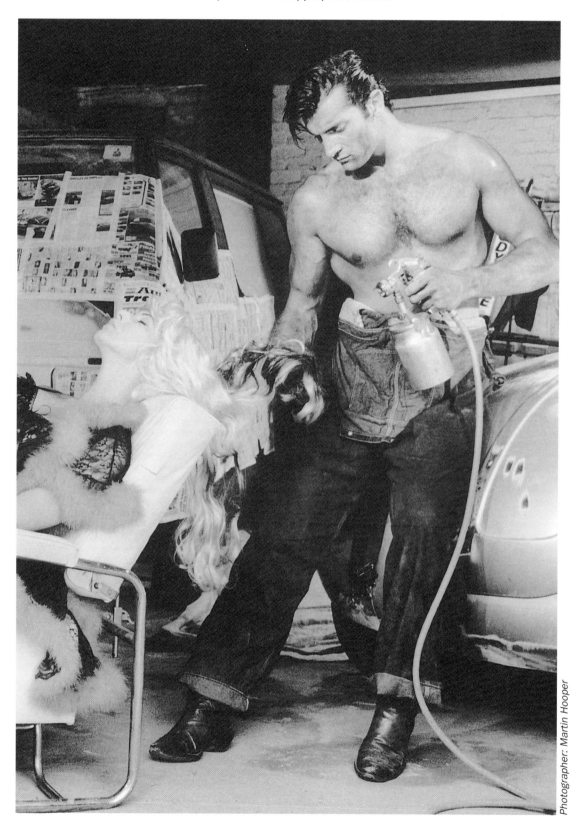

Photographer: Martin Hooper

Printed on STERLING RC-VC, developed in Fotospeed DV10 Varigrade Print Developer, Fixed in Fotospeed FX20 Rapid Fixer and toned in Fotospeed RT20 Copper/Red Toner diluted as manufacturers suggestion of 1+4 for each of the two concentrates and mixed together in the dish to make a single working solution.

Fotospeed RT20 Copper/Red Toner is a single working solution toner. The two concentrates are diluted according to the manufacturer's recommendations of 1+4 with water for each part and then mixed together to form the single working solution.

A single bath toner bleaches and tones simultaneously. As the bleaching agents in the solution remove the silver halide in the print they are immediately replaced by the copper/red toning elements, giving the tone to the print. The longer the print is left in the solution the more toning will take place. Full toning will take approximately 10 mins. If the print is left in the solution any longer, the bleach elements will begin to reduce the density of the image with no further increase in colour. The highlight areas will tone first as there is less silver for the bleach to remove with the shadow areas toning progressively.

Copper/Red working solutions will exhaust more quickly than working solutions of other toners. The exhaustion of the solution will depend on the number, size and the overall density of the prints passed through it. The toning elements of the working solution will exhaust before the bleach elements. This means that if the solutions become exhausted, the print may begin to reduce in density before full toning has occurred as the still active bleaching agents continue working. If this happens remove the print and replace in a fresh working solution. If a print has lost too much density it can be redeveloped in print developer.

The actual colour of the copper/red toner working solution changes from a bright peppermint green when freshly made to a sludgy green as it exhausts. The darker the solution gets the more difficult it is to see the how the print is toning. It is advisable to remove the print regularly from the solution and examine it to see if the required shade of tone has been reached. Regular examination in this way will also prevent any loss of density through solution exhaustion.

Copper toner will leave a yellow discolouration on the surface of the print which visually supresses the tonal quality. This yellow hue will wash off completely to reveal the true copper red tone. Additionally it is advisable to wipe the surface of the print vigorously during the washing process to remove any scum deposits formed during the toning process. Ideally this should be done with wet cotton wool and the print should then be returned to the water to complete washing. If after washing you want to further increase the copper red tone replace the print into the solution until the desired tone is achieved. However, remember that once full toning has occured (10minutes) the bleach elements will begin to reduce the density and shade of the tone.

Printing for Copper/Red Toning.

Without the seperate bleach bath it is naturally impossible to control the bleaching process when copper red toning. The bleach element in the working solution will tend to reduce the density of the print even when the solution is quite fresh. It is advisable therefore to start with a print on the dark side to allow for any loss of density. Therefore print 20% darker for copper/red toning.

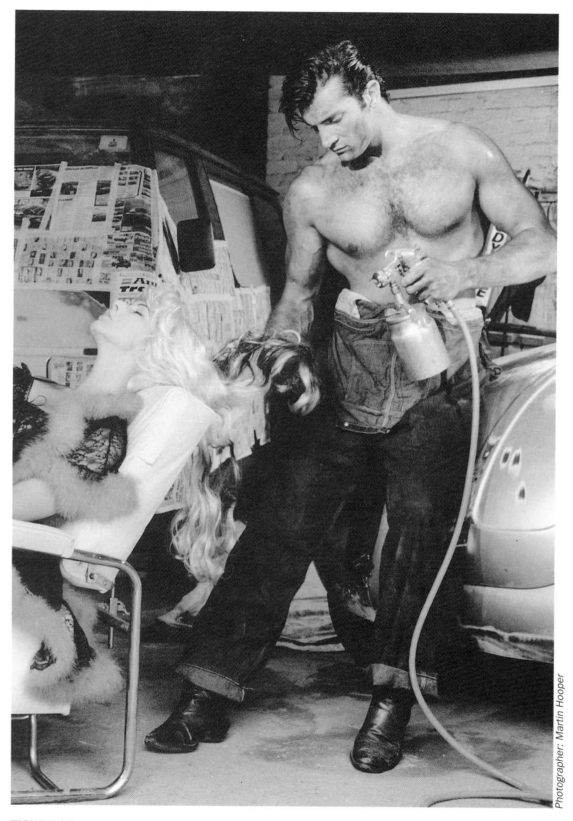

Photographer: Martin Hooper

FIGURE 36
Black & White print untoned

Photographer: Martin Hooper

FIGURE 37

The print was Copper/Red toned (diluted part 1 1+4, part 2 1+4 mixed to make the single working solution) for 4 minutes then washed for 3 minutes in running water and allowed to dry naturally.

Photographer: Martin Hooper

FIGURE 38

The print was Copper/Red Toned for 8 minutes then washed for 3 minutes in running water and allowed to dry naturally

Photographer: Martin Hooper

FIGURE 39

The print was Copper/Red Toned (diluted part 1 1+4 & part 2 1+4 to make single working solution) for 4 minutes then washed for 3 minutes in running water. The toned print was placed in print developer (Fotospeed PD5 at 1+9) for 1 minute and rewashed for 3 minutes in running water, replaced into the Copper/Red Toner for 4 minutes and finally rewashed for 3 minutes in running water. The print was wiped well during the washing sequence to remove any surface scum.

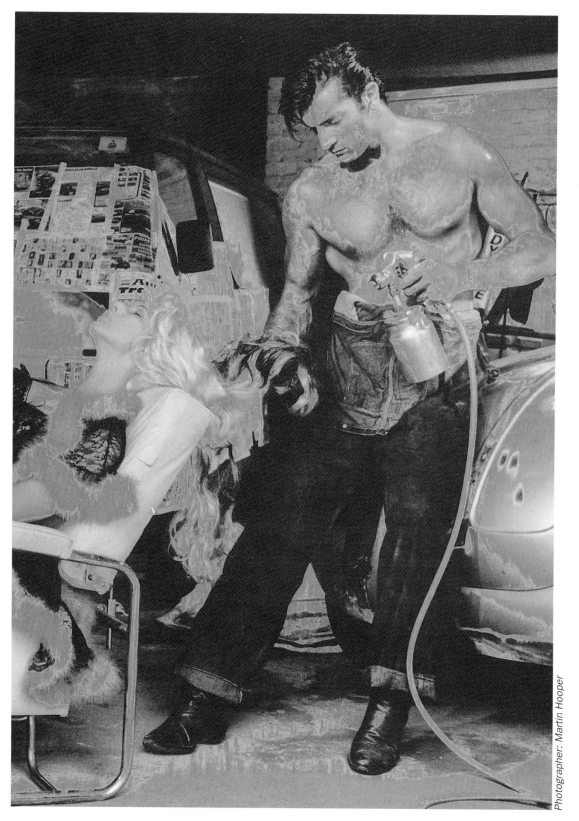

Photographer: Martin Hooper

FIGURE 40

Copper/Red Toned for 8 minutes, washed for 3 minutes in running water then placed in print developer (Fotospeed PD5 at 1+9) for 1 minute. Rewashed for 3 minutes in running water and replaced into the Copper/Red Toner for 8 minutes, Finally rewashed for 3 minutes in running water. The print was wiped well during the washing sequence.

Photographer: Martin Hooper

FIGURE 41

The print was Copper/Red toned (diluted part 1 1+4 and part 2 1+4 to make a single working solution) for 8 minutes then washed for 3 minutes in running water. The toned print was placed into ST20 Sepia Toner Bleach (diluted 1+25) and watched carefully until the required colour shift occurred. In this case it was in the bleach for 2 minutes, however longer or shorter times in the bleach can be used depending on the required results. Finally the print was washed for 3 minutes in running water and allowed to dry naturally The sepia bleach really brightens up the red in the tone.

Photographer: Martin Hooper

FIGURE 42

The print was Copper Toned (diluted part 1 1+4 and part 2 1+4 to make single working solution) for 8 minutes then washed for 3 minutes in running water. The toned print was then placed into fixer (FX20 diluted 1+25) for 2 minutes and washed for 3 minutes in running water. The Copper/Red Tone will diminish in the fixer. The print was returned to the toner for 4 minutes then washed for a further 3 minutes in running water. The print was wiped thoroughly in the final wash and allowed to dry naturally. The solarized effect in the print. has been created by the additional fixer bath. Shorter or longer periods in the fixer can be used for differing effects.

Split Toning with Copper/Red.

Photographer: Martin Hooper

FIGURE 43

The print was Copper/Red toned (diluted part 1 1+4 and part 2 1+4 to make single working solution) for 8 minutes then washed for 3 minutes in running water. The toned print placed in Blue toner (50ml of each part added to 300ml of water) for 4 minutes and finally washed for 3 minutes in running water and allowed to dry naturally.

Photographer: Martin Hooper

FIGURE 44

The print was Copper/Red toned (diluted part 1 1+4 and part 2 1+4 to make single working solution) for 8 minutes then washed for 3 minutes in running water. The toned print was then placed into Sepia Toner (part 2, diluted 1+9 with 40mls/Ltr of part 3 additive) for 2 minutes and finally washed for 3 minutes in running water and allowed to dry naturally.

SELENIUM TONING

Fotospeed SLT20 Selenium Toner.

Photographer: Martin Hooper

Printed on STERLING RC-VC, developed in Fotospeed DV10 Varigrade Print Developer, fixed in Fotospeed FX20 Rapid Fixer and toned in Fotospeed SLT20 Selenium Toner diluted 1+20 for 10 minutes. Washed for 3 minutes in running water and placed in ST20 Sepia Bleach diluted 1+12 for 2 minutes. Finally washed for 3 minutes in running water and allowed to dry naturally.

Fotospeed SLT20 Selenium Toner is a single concentrate diluted to make a single working solution. Of all the toners this is the one that should be handled most carefully and never with bare hands. Either use tongs or gloves. If it should come into contact with your hands wash off with immediately with water .Selenium toner smells stongly of ammonia and therefore should be used in a well ventillated area.

The dilutions range from 1+3 to 1+39 depending on the effect you wish to achieve. The 1+39 dilution is strictly for archival permanence techniques where no visible toning will take place but the print will be made archivally permanent after 15 minutes in the solution. Good washing after toning is essential at least 5 minutes for RC papers and 20 minutes for fibre papers.

Selenium Toner is the most subtle of toners. It creates very subtle purple hues on graded RC papers and fibre papers. The only variable contrast paper to react successfully is STERLING RC–VC which has been used throughout this book. Being a chlorobromide paper, it has a distinct advantage over all the other RC–VC papers.

At weaker dilutions selenium toner will crispen the blacks and give an apparent increase in the contrast without compressing the highlights or blocking-in the shadows. It is therefore important when starting selenium toning that you keep a B&W control print as a reference for comparison.

Selenium toner working solution can be kept for reuse but always store in well labelled bottles and keep out of reach of children.

Photographer: Martin Hooper

FIGURE 45
Black and White untoned print.

Photographer: Martin Hooper

FIGURE 46

*The print was Selenium Toned (diluted 1+3 for maximum effect.) for 10 minutes and then washed for 3 minutes in running water. If a chlorobromide **fibre** paper had been used, such as STERLING FB-VC, then the effect would have been even more dramatic.*

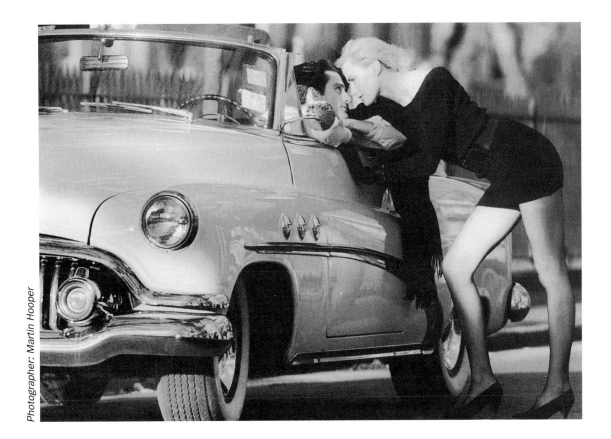

Photographer: Martin Hooper

FIGURE 47

The print was Selenium Toned for 10 minutes (diluted 1+20) then washed for 3 minutes in running water and placed in ST20 Sepia Bleach (diluted 1+12) for 2 minutes, or until preferred effect is achieved. Finally washed for 3 minutes in running water and then allowed to dry naturally. This effect is known as selenium split.

Split Toning with Selenium.

The following prints were all selenium toned initially and then further toned by other selected toners. The selenium base allows the second toner to create a further dimension of shade and hue not available if the second toner is used alone. The effects can be quite exquisite and the technique allows for the most creative use of toner.

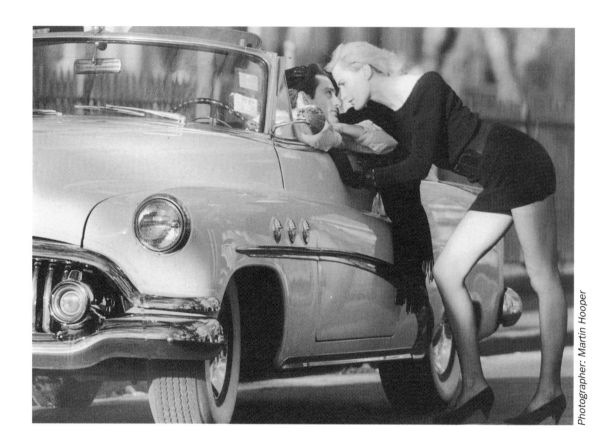

Photographer: Martin Hooper

FIGURE 48

The print was Selenium Toned (diluted 1+20) for 10 minutes then washed for 3 minutes in running water. The toned Print placed in ST20 Bleach (diluted 1+12) for 2 minutes, washed for 3 minutes in running water and placed in sepia toner part 2 (diluted 1+9 with 25mls/Ltr of part 3 additive) for 2 minutes. Finally washed for 3 minutes and allowed to dry naturally.

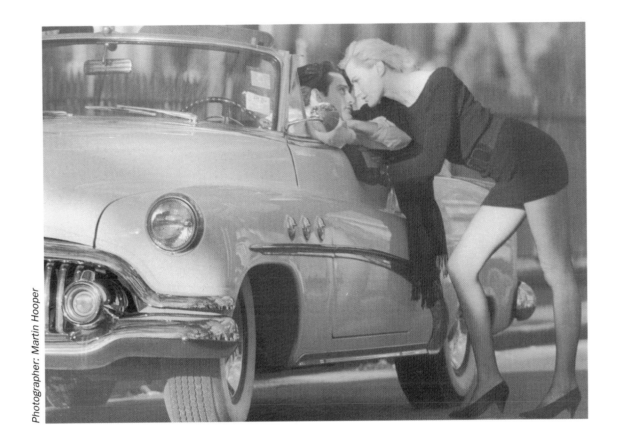

Photographer: Martin Hooper

FIGURE 49

The print was Selenium Toned (diluted 1+20) for 10 minutes then washed for 3 minutes in running water, then placed into RT20 Copper/Red Toner (diluted part 1, 1+4, part 2, 1+4 and mixed to make the single working solution) for 8 minutes. Washed for 3 minutes in running water and allowed to dry naturally.

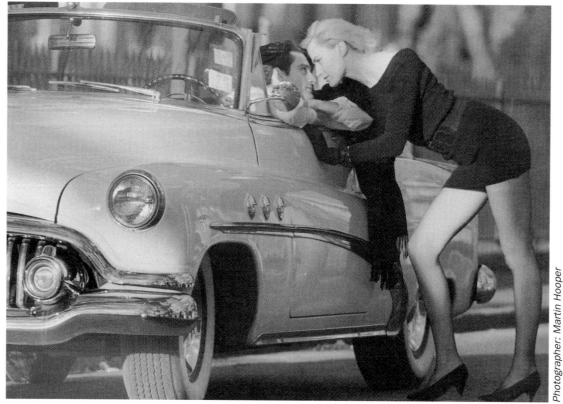

Photographer: Martin Hooper

FIGURE 50

As Fig. 49. but after the copper/red tone the print was washed and then placed in BT20 Blue Toner (part 1 50ml, part 2 50ml, part 3 50ml mixed into 300ml of water to make the single working solution) for 5 minutes. Finally washed for 3 minutes in running water and allowed to dry naturally.

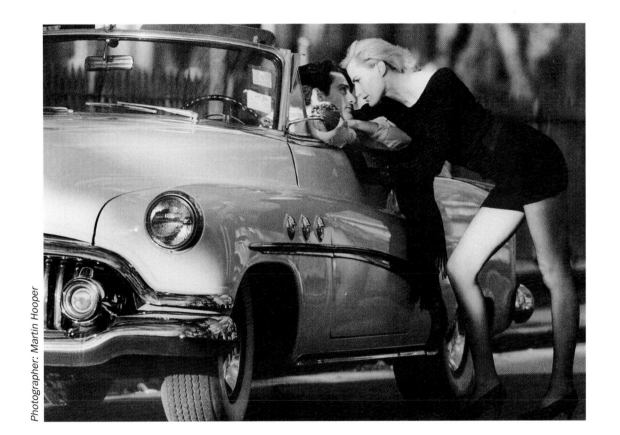

Photographer: Martin Hooper

FIGURE 51

The print was Selenium Toned (diluted 1+20)for 10 minutes, washed for 3 minutes in running water and then placed in BT20 Blue Toner (diluted part 1 50ml, part 2 50ml, part 3 50ml mixed into 300ml of water to make the single working solution) for 4 minutes. Washed for 3 minutes in running water and allowed to dry naturally.

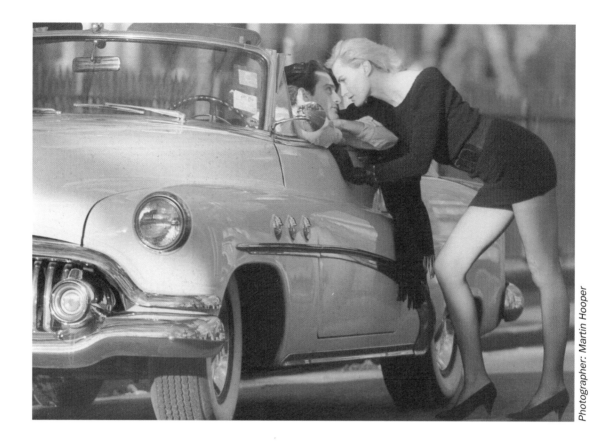

Photographer: Martin Hooper

FIGURE 52

*As Fig. 51 but after blue toning the print was washed and then placed in ST20 Sepia Bleach
(part 1 diluted 1+10)for 1 minute. Washed for 3 minutes in running water and allowed to dry
naturally.*

Split Toning with Selenium.

The examples shown are not the only combinations possible. Times and dilutions can be adjusted as required. Creatively toned prints can be achieved by experimenting with these techniques. Always keep notes. It is very easy to get carried away and forget where you've been!

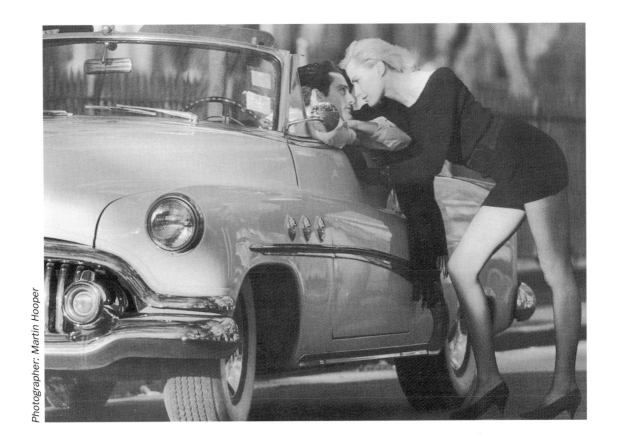

Photographer: Martin Hooper

FIGURE 53

The print was toned as per Fig. 50 . then placed into Fotospeed PD5 Print Developer (diluted 1+9) for 2 minutes until redeveloped. Washed for 3 minutes in running water then back into the blue toner for 4 minutes rewashed for 3 minutes in running water and finally into ST20 Sepia Toner Part 2 (diluted 1+9 with 25mls/Ltr of part 3 additve) Finally washed for 3 minutes in running water and dried naturally. A really rich sepia tone.

MASKING AND TONING

Fotospeed MK50 fotomasking liquid

Fotospeed Fotomask is a bright red liquid designed for application to photographic emulsion. It completely protects the selected area from attack by chemicals and is impervious to water. In this way you are able to retain areas as black and white while allowing the remainder of the print to be toned. It is also possible to sequentially tone areas so that the finished print has more than one tone applied to selected areas. The bright red colour makes it very easy to see where it has been applied even to minute areas and the dye will not leave a stain on the print. Fotomask will not damage the surface of the print. It is removed easily by applying a small piece of sticky tape to one edge of the masked area to lift it, and it then it simply peels off. Once all masking and toning procedures have been completed give the print a quick wash to ensure it is evenly wetted. This will prevent any cockling as it dries. When using the Fotomask always ensure that the area in which it is being used has good ventillation and that you follow the health and safety information on the can.

Photographer: Jane Chilvers

FIGURE 54
Black and White untoned print.

Photographer: Jane Chilvers

FIGURE 55

A black and white print with the hat in Sepia mid-brown The whole print except the hat was masked using a medium brush. The print was then Sepia Toned in the normal way (with 75ml of additive) to give a dark brown to the hat. The toner was able to effect only the hat as the mask had protected the rest of the print

Photographer: Jane Chilvers

FIGURE 56

This time we have reversed the procedure. A Sepia Toned print with the hat still in black and white. This time it was the hat that was masked leaving the rest of the print to be affected by the sepia toning process

Photographer: Jane Chilvers

FIGURE 57

Copper/Red Toned print with a blue toned hat.

Firstly, the hat was masked. The print was then Copper/Red toned (1+4) for 8 minutes to convert all the silver except for the hat area under the mask. The mask was removed, then washed for 3 minutes. Next the whole print, unmasked was placed into Blue Toner for 3 minutes. Finally washed in running water for 3 minutes. and allowed to dry naturally. The blue toner did not effect the copper/red since all the silver had been converted.

MASKING, TONING AND TINTING

Fotospeed DY15 fotodyes

I always compare tinting to painting by numbers. However instead of numbers we have the photograph and its image to follow with the brush. It is very important to use as dry a brush as possible because it is far better to slowly build the colour than try to do it in one application. If the brush is overfilled with dye it will sploge into the print and be either too strong in colour or spread too far. Tinting is the art of using dyes to add colour to the image in a selective and subtle manner. Always use a dye kit that does not leave a surface mark even on glossy paper and that contains a reducer. The benefit of the reducer is that you may easily correct mistakes without having to rewash the whole print, losing everthing and having to start all over again.

Fotospeed Fotodyes are true dyes and have all the benefits described. The front cover shot was tinted very subtley. The lips with red, the eyes with blue and the hair below the hat with brown. No toning has been done to the print and yet the image is alive.

Photographer: Steve Reeve

FIGURE 58
Black and White print

Photographer: Steve Reeve

FIGURE 59
*Prior to being Sepia Toned the areas that are still black and white were masked with the
Fotospeed Fotomask. This has set the print up for a certain charm in the final stage of tinting.
After the mask was applied the print went through the Sepia process with 90mls of additive.
The mask was removed and the print was well washed before being dried.*

Photographer: Steve Reeve

FIGURE 60

The sepia toned print was creatively tinted using Fotospeed Fotodyes DY15. A very fine artist brush was used to apply the dyes. There is a lot of patience invested in this print but I think you will agree that the final result is charming. The Judicial use of dyes just adds the finishing touch. Needless to say the original black and white print was of very high quality which made the transition relatively easy.